METAFLESH

POEMS IN THE VOICES OF THE MONSTER

EVAN J. PETERSON

ARUS
ENTERTAINMENT

The Midnight Channel

Evan J. Peterson dives into the collective unconsciousness via the route of pop culture, horror movies and their attendant complexes of gender, sexuality, mortality, and morality. We are taken on a poetic tour of killers, Final Girls (and the occasional Final Boy), and romp an explosion of horror tropes ... Peterson's poetry moves deftly between comedy and corpses with studied meditations, such that reading each poem feels like sitting next to a cinephiliac genius narrating his inner monologue as he watches each character's life contort, twist, and end onscreen. At times the poetic structure can become dislocating, alternating between deceptively straightforward statements of apparent fact ("Don't try to drive / while you're psychic --- / You'll ruin everything") to a discordant chorus of voices that swallows the reader in its horror...

-Tony Rella, author of *In The Midnight Hour*

Skin Job

Those of you who have long suspected that Evan J. Peterson is the love child of Bette Davis and the Marquis de Sade will find your suspicions confirmed here. Shot in Hollywood and edited in a clammy French dungeon, *Skin Job* is part seduction, part coercion, all pure pleasure.

- David Kirby, author of *Talking about Movies with Jesus*

The PrEP Diaries

"*The PrEP Diaries* is much more than personal thoughts about a drug that prevents HIV infection; it's a bold coming-of-age story about creating a queer sex life that matters. Confronting the societal homophobia, internalized shame, and fear of infection that are familiar to every queer person growing up in the age of AIDS, Evan J. Peterson helps us to imagine sexual splendor as a meticulously-crafted, kind and slutty, wild and loving path toward individual and communal possibility."

-Mattilda Bernstein Sycamore, author of *The End of San Francisco*

"Peterson's (dark) humor and willingness to share moments that he may not be proud of help make this an accessible introduction to a complex but unquestionably important moment in our cultural relationship with HIV/AIDS."

-Foreword Reviews

Temple Laboratories artifact 12

ARUS4101. Published by ARUS Entertainment (Seattle, WA)

ISBN: 978-1-954394-03-2 (ebook)

ISBN: 978-1-954394-04-9 (paperback)

Layout and Editing: Scott James Magner

Cover Art: *Three Brothers*, by Matthew Cunningham (used under license)

Cover Design, Interiors: Honor MacDonald

ARUS
ENTERTAINMENT

METAFLESH

CAST (IN ORDER OF APPEARANCE)

ACT 3: OPENING NIGHT

For the dead and the undead.

EDITOR'S NOTE

Poetry is a collaborative medium, one that reaches through the years and connects one mind to another, hearts and souls intertwined in moments that transcend time and space.

Writing poetry works the same way, and the pieces in this collection are no different. Poets derive inspiration from a variety of sources, and wherever possible, we have attempted to present attribution when some of the work is drawn from more than one brain, and to catalog all such unspoken collaborations.

Poetry is also both an aural and visual medium, and even the way the words lay on the page is part of the magic. As such, you may detect subtle changes between the electronic and print versions of this book—this is wholly unintentional, but necessary for the print edition's majesty to truly shine. To minimize the impact of this process, please set your e-

reader to the default font and text size to get the full effect of Evan's words.

To peek behind the curtain, check out the "Acknowledgements" and "Headstones for Robbed Graves" sections at the end of this book.

But until then, I hope you enjoy this wonderful collection as it was intended, now presented in a single volume for the first time and ready to move even farther into the future.

Scott James Magner
Editor and Failed Poet (tm)
June, 2021

ACT 1: DELETED SCENES

THE WATERMARK

Frankenstein, 1910, J. Searle Dawley for Edison Studios

Even in the credits, my title is handled in quotes, "the Monster." It makes me seem ironic, arbitrary, like the watermark on each frame of film. Their seal is on me, and I'm passed like a strumpet from one scientist to another. One frays my cells while the other scratches my print. Am I this cruel? They prod, hand in rubber gloved hand, putting the sepia into me, watching through a key-hole as I cook. Doesn't "incarnation" even *sound* painful? Imagine: flayed in reverse, muscles struggling to hook the bones, the pulp weaving into locks of rigid viscera. After the operation, my face is so swollen that it hurts to cry. How do they get those mirror shots without ever showing a camera? Film exposes everything; it reveals nothing. A comforting distance between creature and camera. Between the screen and you, dear viewer.

THE WUNDERKAMMER

My body museum, haunted by its own curiosities,

 a cabinet of wonders: tumescent chest,

 a cavity of breakthroughs, bursting;

This torso, cage of ribs, the bird inside grown wan

 since the clipping, stuffed now with batting,

 displayed like the Ashmole dodo.

The double heart clenching, bifid, a wounded

 gypsy moth pumping asymmetrical wings,

 the halves joined not by love but wire.

all of this, and yet no name.

That abdomen, distended marvel, organs in pairs,

 trios, like the shared trunk of joined twins,

 straining the stitches to hold it all in;

three baby livers, pristine, unmarked by absinthe,

 unsoured by laudanum, three milk-fed

 miracles, drawing poisons from this well;

the extra pancreas, spleens, three kidneys,

 the small intestine shortened to make room

 and allow for quick excretion;

all of this, and yet no name.

This auxiliary breast, fat lurker beneath the pectoral,

 leathery nipple, hot as a witch's tit in a

 copper brazier, to suckle infernal familiars;

an extra lung, a sponge for oxygen, drawing plenty,

 fuel for the flames at the core, a goblin forge,

 a forest fire struck by one lucky bolt of light;

this skull inscribed, Hebrew scratched on the inside,

illuminated by the flash:

אמת || *Emet* || Truth

to crack open and rub off a glyph for Death;

all of this, and yet no name.

The brain in its cradle, swollen, backed to the wall,

the caul pinched, cauterized, a barrier

between tissue and fluid, envelope of genius;

my corpus a jar of captured lightning, ultraviolet,

the nerves like taut wires, humming

seven feet from brain to heels—

here is my body, my rarae aves, my cartography.

Here is called only Terra Incognita.

Here be monsters.

THE DEAD STILL HEAR AND FEEL

He whispered to the ear so recently sewn on,

 There's no such thing as fear, nor failed

experiments. He told it secrets, taught

 it science, alchemy. Although the ear

was dead, that ear could hear it all.

He held the face immobilized with antiseptic

 pins. At these cold temples he installed

the nodes, electric spikes. He drove them

 to the brain. He slit and pricked

and hacked and clamped, and flesh

could feel it all—the needle's stick and burn,

the click against the bones, that rap

against the skull. I felt the thread drag through

my holes. You think in death we feel

no pain? You still will feel it all.

He told me I'm a perfect boy, surviving

snow and flames. Undead, I cannot

drown nor die by hangman's rope or chains.

He climbed atop of me and claimed

these things. I heard it all.

I felt the pressure on my chest.

He pinched the skin, explored.

My eyes were drawn but still I saw.

Transfixed in rigor mortis, I

could taste and feel it all.

HOW HE CAME INTO THE WORLD

Der Golem, directed 1915, 1917, 1920 by Paul Wegener

Is this how a golem appears? In cyanotype, a view of the ghetto in blue. Expressionist pottery, never breastfed, emerging un-leavened but fully risen, a miracle three ells in length. Baked shut. Even the hair is sculpted from mud. Now he's terrible, now tender. What can't a fat belt do for a costume of ashes, sack cloth, ropes and rings? The Rabbi-summoned demon gleans the magical word, dusty Hebrew bastardized through Greek, all for German delectation: AEMAET, the Shem, but one of the myriad names for G_d. And then? He moves! What a double mitzvah: locomotion from humble clay, and it doesn't even crack. It takes a bitte schön blonde baby to stop him, yank the star out of his chest and unseal him back to dirt. A rose for the Golem, aromatic velvet against this thudding clump of earth. Three versions. This director is a man obsessed.

ONE BREAST

He did it
because he could.
for science,

for the prickle
of hairs on end,
that *Eureka!*

sparkling
up his spine.
He did it

in caprice,
toying
with my body.

One breast,
just one, pinned
on as if

in afterthought,
as if to say,
Why not?

I still know
the friction
of his hands

against it,
hefting,
gathering,

mashing it
sideways.
He warmed it

with a smack
and when he
kissed it,

it broke
into a rash.
It weighs me

with asymmetry,
sack of fat
bobbing

in its bandage
sling. Once
each month

it leaks, weeping
just a cup
of yellow milk.

CUT UP: HIDEOUS PROGENY

Exploded systems made man beautiful. Relieve me from the sight of sad trash, invisible world. Derange their mechanism, so virtuous and magnificent. A storehouse of ancient errors, I do not wonder.

I dabbled among events: a dead hare, a skeptical chemist to animate hapless victims. The worm inherited its own shadows. An appendage to a former dross, grappling with a palpable microscope and crucible.

I, miserable and abandoned, use names to glut my appetite.

God, in pity, tortured. Mock the stupendous, destroy the lamb and kid of eye and brain usually deemed marvelous. Merely the seat of bodies. I am thy creature, a mummy again endued.

Explode the unhallowed. Express the fluid. Dissect, anatomize, and give names.

HIS NAME IS IN ME

A failed Pygmalion, he always hoped
to grow up a sculptor. *No son
of the house of Frankenstein will peddle
idols*, said Grandfather.

So it was rabbi or surgeon. Such a fork,
and you know which tine he chose.
He always did enjoy the work of hands.
What a show, the electric workshop.

Such obfuscation through illumination.
Before he warmed this body
he jammed a soul into it.
He shucked the still-loose crown

from off my skull and etched
that Hebrew spell inside.
He glossed my lips with frog egg jelly
and spoke three names for God

into my mouth. A spark as tongue
touched tongue and it was done;
life slammed in and I choked
like a newborn. No righteous rabbi,

his ken of Qabalah was slippery,
scant at best, a hobby. But it worked.
Who could believe in science alone?
Frankenstein shred the sephiroth

and broke the golem's mud-mold
all for little me. Little big me,
gross as the tallest savage and thick
with arm meat and tendonitis.

Call me by my father's name. Call me
Frankenstein, the life-stung,
the slick-mouthed, the dead-lipped
abominable. His name is in me.

ALL THE ELECTRICAL SECRETS OF
HEAVEN

Frankenstein, 1931, James Whale

The lab apparatus goes like a Catherine wheel,
slinging its chips of light. *This body isn't dead; it has
never lived.* Hogwash. Every fragment had its day.
Now they rest, waiting. The doctor and his cripple
rob the graves. Frankenstein throws his spade of
earth in Death's face. And the creature? A flat-
headed numbskull, a droop-eyed ghoul with one
sunken cheek. *What are the lives of a few rabbits and
dogs?* Daisies tossed into the lake. The trapper stum-
bles, mouth slack, presenting his sopping offspring. A
mob gathers, toothless, calling for death. No wonder
at such anger; their sky is but a wrinkled backdrop.
Strickfaden saves nothing, resurrects everything.
Raise a glass to the Hollywood ending. A son to the
House of Frankenstein (a living one this time).

THE SHOWER OF SILVER

The din was an orchestra of hiss
and crackle: the pumping bellows,

concertinas of breath;
copper vats, amino tanks,

sloshing on laboratory floor;
the scrape of rusted iron

on clean stone,
shackling me to the slab;

my father's screeches of glee.
The ticking of thunder,

louder, closer, all time measured
by that fatal metronome–

and then I heard the crack.
Godseed shivered down

the collecting rods,
a shower of silver, quickening

me with unalloyed sky.
This was the stroke that woke

the dead. This was Judgment,
announced not with trumpets

but steel drums, the very air
exploding into applause and hail.

The villagers claim it rained
red that night, and I rose

to welcome a New Aeon,
the Age of Ether and Scalpel.

I, the golden homunculus. I,
the first man never conceived.

I, born from sperm but no egg.
The one the storm birthed dry.

THE CREATURE CONFESSES

They claim I fear the fire.

 I am a salamander!

They claim I eat their children.

 I shit no little toenails!

They claim I murdered everyone

 my father ever loved.

His baby brother? Not my thumb

 on that white neck, despite

his grieving rants. I did not kill

 Clerval, his death the work

of thugs (no small coincidence). Now

 Elizabeth, my father's doll,

Oh yes. I did kill her.

 You bet your hands I did.

She strangled little William

 and framed a nurse to lure

her lover back to her red arms.

 I returned that harm.

I'm decent; it was quick.

 I held her by her maiden head

and popped her like a whip.

 To know the breathlight glow,

then snuff it, hear the wheeze

 and cease—we two

had much in common then.

 I reached into her chest,

as Father reached in me,

 and took that part of her

he loved the best,

 her killer's heart. Just meat.

I held her redness out to him,

 a killer put to death

at last. I did this but

 to make amends,

but Father's stomach turned.

 Alas.

IN THE ARCTIC

I breastfeed an orphaned narwhal,

 calling him to me, his budding horn digging

my ribs. So new to nurture, to cradle, to use

 this joke my father sewed to me with spite

for care instead, issuing warm suds of fat,

 assuaging that calf's lonely, monstrous

hunger. *Slip of pup*, I say, *little monster.*

 I know your horn hurts you. You wail

as you teethe, this tusk penetrating the fat

 of your lip. Soon, you will know to dig

through ice, to find the ley line in the spit.

Your horn is lovely, a tool to use.

Monodon monoceros: not a sentient ooze,

neither giant nor portent, not a monster

but a unicorn of the sea, elegant despite,

no, because of that snaggletooth. No whale,

white or blue, ever displayed such dignity.

Majesty is not always synonymous with fat,

with bulk. My own overgrown body is fated

to be fit, hard muscled, yet it's used,

gutted by fire and the scalpel, a Hercules dug

through with needle and thread. Monster?

Demigod! What other man wrestled whales

and held his breath for three hours? Spite

inspires. I've chased the doctor despite

 the cold at the world's crown. What father

goes so far to outrun his son? James Whale

 will leave this part out, budget abused,

but imagine it: a darkling on a field of monstrous

 snow, blasted black on white, dignified.

On the ice, I nearly find some dignity,

 this baby narwhal, this chance to bury spite

for the needy mouth of love, to demonstrate

 I am not less, but more than a man, father

and mother to this orphaned calf. *Use*

 my body to keep you alive! I wail,

but my baby narwhal can't. In he digs,

 but his belly won't use my milk. He spits

it up, rancid fat, and dies writhing like a monster.

ALCHYMY (THE ELEMENTS)

Flinting the fire. Cutting the ice.
A crest of fire. A crown of ice.

Fire like the hair of Heaven.
Ice like the toes of Hell.

Heavy with fire. The stink of ice.

A Fool for lightning. The Pope
of snow. My blood of lightning.

My bowels like snow.
The snow's cradle. The lightning's

child. Lightning and his booming
bride. Snow, the never lonely army.

A storm of rampant horses, all on fire.
A dozen grizzled sailors locked in ice.

The slap of fire. The kiss of ice.

Cracked by fire. Healed by ice.

My jaws of lightning.
These teeth like snow.

Tupped by lightning. Slicked by snow.

Cracks like albatross through glacier.
Caves like oozing ears of mountain.

Mountains like cathedrals
to the oldest gods. Glaciers

like diamonds on the goddess' throat.
The surgeon carves the glacier,

just as dynamite carves
the mountain. Bald fist

of the glacier. Rough skull
of the mountain.

Snow and snow upon the fire.
Glacier scrape the mountain's rime.

Squeeze the ice and freeze the lightning.
Find my father. Snap his spine.

LITTLE PINE EYE

Pinocchio, 1911, Guilio Antamoro

In Collodi's original tale, the unborn log feels the
burn of the scalpello, crying out. Some endure chisel
and adze just to look human. We massage the grain
to soften it to flesh, but the termites are already in.
The nose dry-rots from off the face. Carpenter ants
take off with our lips shared in their pincers. Pray,
my fantoccino, that some cyanotic blue fairy will
hear your mulch of tears hit the earth floor and pity
you, grant you mortality. Pray to live long enough to
die a man. How many paths to that eternal forest
fire? Recall that fire is a miracle, the gift of
Prometheus who, like Film, stole light. Fire blasts
your shadow into sudden cleansing drama, flood of
shine into a darkened wood.

FRANKENSTEIN TO FRANKENSTEIN

Dear Maker, you god you, reaching into the grave
and yanking like a hook, lifting me from the abattoir
as if I were Jesus, sour by the third day, your favorite

boy fallen down the well—don't you find your own
self Christlike, that act of quickening maggoty
Lazarus? Between father and son there's slippage,

egos seeping across the membrane. Rather Oedipal,
but with the mother nixed. Gods, women; who needs
such things when men create life? Adam sans Eve,

his mud gritty yet slick in the creator's fingers.
He, like me, began as a lump of coal in Eden's
stocking, shaped into a toe, then a foot, then

a miracle. All it took was a little divine breath
to blow him toward that sin of seeking, sucking
knowledge from fruit. A god creates men in his own

image, then wonders why they want to be gods.
A new trinity: Father, Son, Holy Lightning, each
striking the anvil, itching to temper, to create

chaos if nothing else. Father, did you know they call
me "Frankenstein?" Not because I'm your son,
nothing so formal, but in the way we call Tesla coils

"Tesla coils." An eponym, like "guillotine,"
"shrapnel," or "Parkinson's." The palsy replaces
the deposed doctor. So—whose castle is it now?

ACT 2: CINÉMATOXIQUE

DUMBSHOW

The Cabinet of Dr. Caligari, 1920, Robert Wiene

I'm struck dumb by the cinema, these theaters haunted by music. But this is hardly Wagner; it's stolen vaudeville. Sideshow invalids invite stares, not witness. Watch Cesare, the kinky somnambulist, hands flopping. It's metacinema: he's on screen, imago, as he dreams films against his own wet eyelids. In night terrors, he's a secret T-Rex, exhumed, brought home to nest, such tiny faggots for arms. Scurrying along alleys, he stumbles through a pitched world of shadows. Not for me. I'd run. I'd windmill my arms, smashing little old crones beneath their chins, splattering children like ripped fish. Set ablaze by angry villagers, I'd crash about, knocking over scenery, brightening my stage and costars alike. Every actor costumed in orange, and an orange set, orange props, all the orange bloody world a flaming stage. In dreams, no one ever really burned.

CUT-UP: RETROFUTURIST MANIFESTO

Poetry must be odious. Dissect the blow with the fist. The splendor of its red sword made man beautiful with violent spurts of omnipresent speed. Beautiful ideas kill eternal, detested form. The only cure of enthusiastic crowds.

Factories suspended. Moribund palaces, so vicious and base. Propeller sounds the lifeless clay, gangrene of professors, and the living animal. Great-breasted locomotives a filthy type. Demolish museums, the wonders a storehouse of ancient errors. Devour smoking nocturnal vibration; eat and be refreshed. The applause, crowds agitated by unhallowed celestial grime.

Bow before marvelous fetter. We are already living in the seat of beauty. There is no masterday. Mock unhallowed arts destroy the beauty of speed. Exploded games. Museums crawl.

Anatomize, and Space died yesterday. I am and struggle. Eat God, in pity.

DIE PUPPE

dolls, 1934-1975, Hans Bellmer

My skull crumbles to sugar at the sight of them. I see
and wallow in my own spittle, imagining a touch of
wooden toes, of running fingers along their seams,
tickling those plaster breasts knocked out of place in
Dada frenzy. The body cartographer whittles little
girls from soap, from clay, from driftwood. Each a
sweet Lavinia, her branches snapped. Do they smell
like daisies and petroleum jelly? I've only seen
photos. False twins; falsies; buttocks doubled as
breasts, legs as arms. One tin eye on a cotton cord. If
I pulled, might she call me *mutter*? If only he
designed them like clock-work, precious Salome of
Metropolis. If only he rigged each girl to unbuckle
own her back brace, curl down her own stockings.
But girls do rebel. Best to leave them hollow. Each
tiny rubber face is perfect. Nothing behind it to illu-
minate the dark.

GODS AND MONSTERS

The Bride of Frankenstein, 1935, James Whale

Sorting out the sequel: monsters are difficult to kill.
Hair and makeup by burning windmill. Trailer: *The
Monster Speaks!* Some revelation. Shuffle in new
characters—queer old sorcerer, growing imps like
fungus from his own gray spore. A blind man of the
forest: friendship foiled again. *Damn it.* Ever seen a
dead man drunk? How about crying? Check out that
bride, Mary Shelley back from the prologue for more,
Elsa Lanchester in a fright wig to end all fright, her
gilded jaw the golden ratio of stitches. Even the lab
is, herself, a character, womb of stone, mother elec-
tric. Un-expected ending: the monster has the last
word and an heroic death. *And don't you owe him
that.*

THE BLACK DAHLIA REVIEW

Elizabeth Short, surrealist sculpture

1947, Anonymous

Such are the perils of show biz. The illusionist
slipped, sawed you beyond the help of magic.
Shudder, kick-step. Thighs peppery with dried
blood. The line of paper dolls: a cancan, half
the chorus girls, but not one high heel gone
from the footlights. Examine the Chelsea grin,
razored in like Man Ray ironing. Your star has
risen, making headlines, your face a work of art.
Newspapers scream: *Werewolf Murder!* to rave
reviews. Dearest Elizabeth, what rough beasts
came round at last and ran their train on you?

What comb of eye-teeth dragged your silken
hair? Now the she-wolf suckles no cubs, teats
cut out like front page news, a poster girl for
Grand Guignol. The haruspex had you, sprang

your entrails, but what did he divine? Occult blood. Spatter of local fame. Look at all these men lining up to see you this morning. Here we go, Elizabeth—Lights

Cameras.

Grin.

MADE FOR TV

Frankenstein 1970, 1958, Howard W. Koch

Cue the pop anachronism:

> *Uh-huh make me tonight*
> *tonight*

> *make it right!*

Atomic.

Bad timing runs in the family. Karloff
does the best he can with rotten lines.

[science without conscience]

A new brand of energy, this radiation.
A milestone in medical imaging. Sight
of bones without any slicing.

[split yolks / doomsday cakes]

Scalpel hypnotism: some men
are mesmerized by anything shiny.

And then—Uh-oh! Zombies!
Hydrogen cadavers!
Hazmat suits for everyone.

Think of your career, darling

and don't cut the fog.
We need all the atmosphere we can get.
Ingenue after ingenue, they fold
to radiation. One more take:

let's have another stab at it
and see if we can put the film
out of its misery.

GO NAMELESS

See: Herr-Frau Dissendat, the living

 collage! Greatest director

of the end times! Lay a red carpet

 in Nottingham lace, a name

[what name?] in lights:

 on marquees: spritz-painted

on subway walls. Gasped in terror

 behind the Hollywood sign.

"Little Orphan Zombie" Call me

 after my eye or breast, left leg

or right lung [our name is Legion,

 for we are many] I'll go

nameless before they call me

 "Frankenstein" again, that hex

belonging to no part,

 yet sutured always to the whole.

Stitches tattooed to each side

 of my stitches, I cop a feel

and call out nothing. The virgin gauze,

 the skin graft veil—am I not

my own bride?

 ['Tis all one flesh]

DRIVE-IN PALIMPSEST

Well, color me puce. Or better yet,
chartreuse. The blush into ~~stain~~
pigment: a different sort of spectral.

My transition from library to Silver
Screen has been ~~predictable~~
unpleasant. Self-obsessed palimpsest,

I have names scratched over names,
dented pages, fogged frames. "Warhol"
over "Morrissey." "Shelley" across

"Godwin." "Walton" over "Frankenstein"
~~over nothing I have no name~~.
Incest is stricken from the record,

a bridal cousin now adopted orphan,
and the politics drowned in the bay.
They ~~rewrite~~ correct me like history,

like Texas textbooks. The whole
of human knowledge reduced
to a pop-up book of ~~figments~~

folktales. Books become three-
dimensional at the All-Night
American Drive-In. Good teenagers,

put on your 3-D glasses
and take off your clothes. Your eyes:
mismatched as mine now, one blue,

one red as a ~~Communist~~ Martian.
I never spoke ~~French~~ freely.
I used to be ~~Swiss British~~ somebody.

FRANKEN BERRY?

Breakfast cereal, 1971, General Mills

Please tell me you're joking. His eyes are two port-holes, all of him a portmanteau so obvious we hear the hinges creak. At one side of his head, a pressure gauge emerges. A steam whistle blows at the other. His pink complexion is like a phial of bloody milk, and his fingernails are strawberries. *Strawberries.* An outrage in hot coral. Each bowl hemorrhages, rosy with toothrot, while we sing in praise of color televi-sion. Each box promises a prize—a choking hazard—a werewolf kazoo for summoning the fruit brutes. They slink out from behind dumpsters and snap you up from the playground. They twist off your head like a milk-bottle cap. What a sweet pack.

I HEART UDO KIER

Flesh for Frankenstein, 1973, Paul Morrissey

All hail the miracle of 3D! The rat's eye view of the housekeeper, giblets dangling through the sewer grate. Then—nipples plunging out to you. Who cares if this one can't act? He's Aryan. Eugenic. Off to the bordello to slum it with the peasants. Then it's cinéma vérité! Hire hustlers to play hustlers! Get addicts to play addicts! Shoot them shooting up in the bald vein of daylight. The quiver of electrified flesh. Lustrous hair. Morrissey makes it look so easy. I could make a film [and make you my star]. Only the choicest flesh selected from dailies. Heads will roll, wobble right off the ragged stump. Can't your stitches hold for eighty damned minutes?

BRING ME THE HEAD OF CLORIS LEACHMAN

Young Frankenstein, 1974, Mel Brooks

Before the director collected flies, there was Frankenstein. Before Dracula lapped the spatter from a virgin jugular, there was Frankenstein. The genre prototype, a ghost story haunted back to life. Brooks' monster is a gentler sort of moron. Still, the villagers itch to boil him in oil. At first, the ladies and other nervous persons fainted as Karloff appeared on screen, but now they choke on jokes. Now the hunchback fills his mouth with mink. Fear erupts into laughter—should I be flattered? Ambulate, heel to toe. Plop on a top hat and mumble on the Ritz. But hush now, Frau Blucher. You'll spook the horses. Soon they'll be whipped into glue.

CREATURE OF THE NIGHT

The Rocky Horror Picture Show, 1975, Jim Sharman

I crashed the theater tonight and popcorn flew. I thought I dreamed the picture; it melted like a tab of LSD and everybody loved me. A monster flexed like Flash Gordon in gold briefs. I ripped off my disguise and leapt before their screen. I lost my virginity in the back row, my titty out and all. My girl—I guess she was a girl—sang, *Hot patootie, bless my soul!* So I did, sucking her earlobes and spluttering cold. By then, Sarandon's eyes were big as my fists. She made love to the monster! The doctor died for glamour! See? You people break the laws of science for love. You slay each other with pickaxes for love. And so I've decided to make every one of you love me.

INTERMISSION

Allow a pause.

A little calliope and a trip to the lobby.
Everyone up for a stretch, a piss,
then unwashed hands pointing
at nonpareils, gummies behind glass.

By now your eyes must be silvered over
by the screen. Rest them. You've no
idea how easily they damage.
Of my own, one is blind. It can't know

its own poison green in a mirror.
The other lolls, blue as asphyxia—
that necessary. But enough
about me—some popcorn, please.

I like the half-burst kernels best—
hard enough to break a tooth,
and tonight I did.

The thrill of surprise:

Chomp, chomp, shatter.
One hundred and some odd years,
and I've never lost a single molar.
It's nothing. Nothing at all.

Now, the lights dim.
Back to the show.
Lift the scrim.

ALL YOUR GORGEOUS GARBAGE

Give me all your garbage: all that useless

 ganglia, fingernails, and jowls,

your rattling sacks of milk teeth,

 your honey-colored crusts;

your vivisected hummingbirds,

 cracked rubies, orchids rotten in the pots,

all your diced-down starfish, all your broken water,

 all your salty stillborn;

All those hot-twitch forceps, buzzloads,

 knives browning in the snow;

all your mutton knuckles, all your broken beakers,

 blown fuses, lightning rods.

I want all your spent scalpels, sunk into bone

 and snapped off, all your tickled ribs,

all your tubes and bottles, ground beetles,

 aphrodisiacs, and tiger penis soup;

all your pulled weeds, beheaded dandelions,

 all your thistle snips.

All your blackened timbers, all your failing

 windmills, all your fisted fate;

all your tumbling Towers, all your Tarot omens,

 ripped up Lovers, Hanging Men;

All your plugs and sutures, all your infinite futures,

 your shards of crystal balls.

Give me all your oxides, give me all your horse hides,

 all your luminescent mold.

Bring your mighty torches, everything that scorches.

All your spitting villagers, their daughters

steeped in lakes. All your brass collection plates,

all your expedition crates,

your crumpled maps and hatchets, your mummified

remains. All your fogged barometers,

posterior thermometers, all your bloody piss,

all your parts and members, your work

reduced to embers, all that you deserve—

all your gorgeous garbage give me

everything you've got.

ACT 3: OPENING NIGHT

THE CINEMA OF CRUELTY

an interview for two voices

 issuing from a single mouth

Monsieur Monster, please explain the Cinema of Cruelty.

> *A design to murder magic. A stately pleasure dome defiled. The poetry of meat.*

I see. And what might the audience expect to find there?

> *Stroboscopic surgeries. Footlights exploding, freezing actors frame by frame. Scarab beetles smashed against the screen. A shadow cast to mime the film.*

Does the Cinema have a mission statement?

The inside of the body is but the outside captured. Distinctions being a marble game for hydrocephalic children. Cruelty being the copper drainage tube driven into the moron's skull. Audience participation being the only entry fee.

Is that then the goal of the Cinema, to relieve pressure?

All enjoy the smells of their own soils. Each checks the pot to see what he's made. Your own filth is never quite as profane as another's.

Monsieur Monster, you speak in spongy riddles.

Of course not. Nothing is as ugly as the teeth, shredding expensive meals, mashing them down to a monochromatic lump to be squeezed lower, chamber by chamber.

I'm not sure I understand.

Donate your remains to art.

What?

What?

THAT'S ENTERTAINMENT

Theater should punish actor and audience alike.
Every seat rigged for spring-loaded
mortification. Acetic forms of entertainment:

Live: powdered genders and astral tectonics.
Stunt casting.

The audience performs its role willingly{?}
They've signed the waivers to gaze.
So gawk at the reversed burqas—

only the women's eyes remain covered.
The bloom of control. Fear unwinds
into need.

[the view of the corner from the corner]

It says right here, *No one*
who expires from fright
or violence will hold
the proprietor at fault.
No compromises.

All extremism being a comedy of errors.

[self-satire blown to smithereens]

Tied to the chair by your own hair.
We pay the ticket. We take our chances.

DYSCEPHALUS

The Elephant Man, directed 1980 by David Lynch

My head, but not *my* head. Knobby pumpkin spinning on a pole, putty, sticks, and wire, a Harryhausen puppet. And my greatest discovery—A latent medical anomaly: *dyscephalus.* Coined it myself. *"The disorder of extremities in which the subject's head, seemingly attached, is clearly not the head belonging on that body."* Lately, I've devised the means to shuck it and release the handsome, sweating face beneath. A slow melt, revealing the actor embedded in all that wax; or yank a stiff corner of gauze and unwrap the death mask; or worms to eat away the outer onion. Medicine is messy. A hospital is no place for secrecy. O, throne of sense and senses! Hateful helmet! Why can't I pull you off?

BOX OFFICE POISON

Mommy Dearest, directed 1981 by Frank Perry

She's not mad at you; she's mad at the dirt. At the filth. At the way blue tile never looks completely clean. She's livid with the rose garden, going at it with shears. She sneers, summoning the axe like Hollywood royalty, legs crossed, demure even as they drive her to the guillotine. Don't I know that feeling. The tightness around the jaw, skin taut from a good old scalding before plunging my face into ice—for the fans, of course. Glamour is a monster sewn from red carpet dresses and bloody bathroom rugs. Some years, hurrah! It's *Mildred Pierce*. Others, it's *Strait Jacket*, and you're stroking William Castle just to play a victim. One night, dining with Colin Clive. The next, and it's *Frankenhooker* till dawn. I remain, like Joan, the Monster, and when I ask you to call me that, I want you to mean it.

THE PISS TEST CATHEDRAL

A clinical detachment at the altar:

> Sudden drop in body mass.

The cathedral provides

> creative freedom

seldom found in surgery:

blessings

of tendon,

unheard-of structures

blossoming from the backs

of knees.

A perfect set; it even smells

authentic. Frothy.

Scenes on the gurney:

unlikely uses for rubber tubing.

Certain worship under lock and key.

Here,

patients are restrained

to prevent incidents.

The hospital doubles as cathedral,

triples as soundstage,

click/clack

of toggling switches.

The censer swinging like a pendulum,

smoking the bacteria

out of the room, sterilizing

the dropping blade.

The simple rate flesh on the scale

of disgust to arousal,

stomach contents to rippled muscle,

as if the two exclude.

Fear is but misplaced desire,

bodymeat merely weight,

salt-jacketed and served.

Vermillion cells tumble

through tubes—

let them out

and it's outsider art.

Hot scarlet sinking into snow,

vulgar scent of copper.

The body excites the catheter.

Fixed into position:

the butterfly spreads his legs

to receive the jeweled pin.

THE BANDAGE MOTIF

It sneaks up on you like brain cancer:

 the mutating score,

 the Bandage Motif.

 Notes prick silence,

a soft sting at first,

 then strike like a branding iron.

A pattern emerges like a handful of teeth

 finding their sockets back in the mouth,

 staccato assembled to sense.

Most scenes call for quiet,

 blank tablature waiting

like a bride,

ready to pique the staff

 with shrieks–

 no tidy montage.

Record the score in your private lab:

 trombones

 and snares,

 so it feels

like you're run through with brass.

 The hammers of the harpsichord

 could break your jaw.

 Suffering is incidental.

 Incidental sounds

spring up like jets of fluid:

 gzzzt-gzzzt

 of electricity,

 distant howl of penned mastiffs,

 klonk of iron

 chains as thick as a healthy leg.

Whip crack, jangle, rasp,

 groan of the ceiling's collapse.

Give us a merry melody, the thud

 of smashing

 insects and the *squelch*

 of organ

 meat.

God loves, man kills:

 my darkmotif.

When fingers fall away,

 I'll play the tune with my toes.

 With my tongue.

I'll beat the drum with stumps.

CUT-UP: OPTIMUM SHELLEY AUTO CRASH

Their eyes produced photographs. Slow-motion intercourse during a) campaign speeches, b) invisible world events, c) motion picture studies. The mouth-parts of the crucible. Musculature played the role of husband, insurance salesman, rigidity, etc. Damps of the grave conceived in prepubescent terms by slight.

HAIRSTYLE. Sites for excitation construct the optimum facial tones. Reagan and the dolls, but my form, the sex-death posture, even with mature adults. 82% of hapless victims, a dead hare. Motorcade attacks of the eye and brain.

Maximum audience excitation for the worm: Unretouched photographs of a churchyard. I do not . I dabbled among deprived children—aural, orbital. Model psychodramas to animate Reagan's head. A receptacle.

Exploded trash fatalities. Dolls crash facing the microspeeches. Marked photogravel. 65% of maw the lamb dissects. Beauty of . A mum hare fixation on windshields and useless arousal. A marked erotic effect upon the plastic children. The church merely a hairstyle.

DIE YOUNG, STAY PRETTY

I was a teenage Frankenstein, thighs
like bolted iron, my face and shoulders

Today my breast came off

pockmarked by sebum and the stitch.
My back: a toad's, giving birth to bubbling

It slid like a slug down my belly

pimples. Forever adolescent, I snapped
my ankles, tripped over my own platform

and with a magnificent suck

boots. My heart was some punk band's logo

safety-pinned against my chest—

> *it flopped onto the ground*

halfway out, exposed to air, anchored
to one nipple by a purple bulldog clip.

> *I became a man today*

REBIRTH IS ALWAYS PAINFUL

Re-Animator, directed 1985 by Stuart Gordon

Today we play the meat card. The sticky. Today
innards uncoil like vines and seize you by the ankle.
The best elixirs glow. [*teenage lightning*] We bless
the syringe and push into epidural space. [*Flush of
bioluminescence: hormone geyser: phosphorescence*].
Howling like a newborn, dragged back from the cold
and liquid afterworld for another go at breath, a
second death.

Today we press some flesh.

Ancient question: when dead boys walk, do they
know poetry? Or is it all just hunger, brains, and
meat? Don't fool yourself—a zombie does feel pain.
It's the pain itself that's lost its meaning. [Cut]

EVERY NOW AND THEN I FALL APART

Well, pop my stitches and crack

my fat; last night

I lost my nose. The mice

 made off with it, proving me

 little more than a bag

of protein,

a sack of feed.

Each morning I'm a heap,

 wondering what scrap has rolled away.

This is how I end up in the bath

 days at a time.

I leak until water congeals

 primordial soup prima materia,

fermenting new life.

 If I stuck still

 for billions of years, would my bacteria

 breed into algae,

 starfish, and salamanders? Into pterodactyls,

manta rays, and mammoths?

 Into

 men?

They would map me, prove I'm not flat.

Soon, they'd make new monsters

 to wonder

 as I do, *Who is the ubermonster,*

 the ur-wretch on whom I grow

 and kill and shit and fail

 to die?

My clockwork will finally wind down.

Perhaps I'll fade

 another image on exposed film,

and flies will tidy up the mess.

 What is disintegration but the breaking

 of a chorus,

 firing the weakest singers?

 I don't need ten fingers.

My only hopeful member has detached,

 bobbing on the surface of the bath.

 Poor scrimshaw banana,

 scored,

 sweet with rot.

Another root in the soup.

MUSEUM OF OBSOLESCENCE
(WUNDERKAMMER REPRISE)

I belong here, cooling in the museum,
my collection of outdated vice and devices.

Among obsolete inventions,
amidst the telegraph wires and phonographs,

the lamp oil and tallow candles, with ice picks,
sleigh bells, horses stuffed with sawdust,

replaced by steam, steam replaced by diesel;
with zoetropes, kinetoscopes, an abacus, a sextant,

sundials, grandfather clocks, and Schwarzwald
cuckoos. I take comfort in dead languages.

In cuneiform, in the stylus.
In papyrus, in parchment, in codeces.

In umlaut stamps stolen by Gutenberg himself,
in typewriters. I've catalogued them all:

merkins and termite-chewed prostheses, chastity
belts and phrenology busts, palmist's charts,

chiromancy, reflexology, nostrums.
Quackery, snake oil, the mountebank remedies.

The rows of apothecary jars: liquid cocaine,
paregoric, ether, blood purifiers,

dried placenta, tartar's lips,
Tycho Brahe's own gold nose,

quicklime, henbane, powdered antlers.
Aborted plans and failed homunculi. Behold

belladonna for glittering eyes, hair tonics,
lead cosmetics, spring-loaded wrist slashers,

six blades apiece to preserve the pallor.
I have ammonites, trilobytes, fossils predating

the Flood, statues of saints,
Priapus with prick in hand.

Crucifixes against blood sippers, silver
bullets, human skin tattooed with glyphs—

Eye of Horus, Sacred Heart—
didn't save their hides. Each shelf

is shoved full with calfskin condoms,
model zeppelins sans hydrogen,

sans sizzle, and vestigial organs:
coccyx, eyebrows, wisdom teeth,

earlobes. The thumbscrews smash
nothing, the iron maidens bleed no one.

The pendulums descend through clean air.
Electroshock units jazz no one into health

or disclosure. Such a waste.
This is what is left in the tomb dust,

the mummy's brain scooped out and tossed.
This is the romance of obsolescence,

all things patinated, the patents long
expired. Tell me I don't belong dead.

ELEGY FOR THE TONGUE

He wilts in his bed,
turns white,

fat even as he collapses.
Slickness once

was his domain,
wet comfort,

clean slime.
Jehovah's little fish,

he wiped the mess
away from lip,

purged ice cream
of sprinkles.

He could've slipped
up, up a torso

trailing graceful rivers.
Now he drags, clammy,

and no necks yield.
What foetid egg

degraded this purity?
What syringe pulled

the moisture out,
the warmth,

and shriveled him so?
Poor, dead organ,

desiccated squid.
Crumble him into tea.

OTTO; OR UP WITH DEAD PEOPLE

2008, Bruce La Bruce

A hasty transfusion: tube ripped from arm

 and spurting: hot jets:

 Your meatkiss collapses, a nethermouth,

porn-vacant,

 a body waiting to be signed.

Facial wasting: lipidystrophy [no fats]: slipping

 the elastic, eyes sucked back and teeth

 plucked of hemoglobin, but please

Leave your torso intact. Fresh and chiseled,

a newly struck tombstone.

Infrared doesn't lie; aren't we all hot

for the right Predator?

Fingered meats on pile

in the abattoir.

Who's king of the heap?

[I mean, come on—you've fucked worse

than zombies, right?]

No pic, no chat/no fats/

no femmes/no Blacks/no Asians/no

Humanity

Skin your head, snout to glass.

Lose the jackboots, unstrap suspenders.

bring your teenage angst,

your sperm und drang.

Starring the Zombie as "Unextraordinary"

mere jerk of nerves, no different than life

your capacity for reason untainted

by embalmer's fluids [hot jets]

Nonetheless, the undead have difficulty accepting

suicide. The Revolution

is your boyfriend. The Apocalypse:

just a fuckbuddy.

When there's no one around

Except for the Policeman in our heads

Raise the dead like a greased fist. Power to the people.

Yeah there's no one around

Let's pretend that everyone's dead

A FLY ON THE LENS

The Fly, directed 1986 by David Cronenberg

I began very neatly: The camera loves me. Then
assimilation, fusion with the exoskeletal zoo. If film is
made of silver, what is video? Rust? A doctor turning
baboons inside out. They always turn experiments
on themselves. Cue swollen violins, followed by
spectacular wreckage. A zig zag of warring DNA,
splice of two films. Skin is grafted to chiton [*the
camera loves me*] Proteins unzip, helixes rip apart
The insect falls in love with his own deformity
Pregnant with sutures A vat of thread
Nibbling at this silver stump of evolution.

Test audiences need more convincing

[*Nude scene*]

[*That'll put asses in chairs*]

[*I am made of rust*]

Zoom in tightly

[*the camera loved me*]

I began very neatly.

ACCEPTANCE SPEECH FOR A POSTHUMOUS OSCAR

Thank you for this secular exorcism.
Thank you for the poltergeist at the podium,
for the ectoplasm dripping from the mic.
Thank you for clutching your pearls.
That last shot was, I admit, a doozy.

Thanks as well for my body, which is a life-sized map
of my body. No borders without war.

And where would I be without my remains
splayed across the light table,
reduced to proofs and contact paper?
Without the Chelsea grin?
In the ooze, that's where. In the sepsis.

Thanks for strands of mucus draped
between my derelict halves.
Thanks for terminal interrogations,
for infirmity. For shoving the adrenaline needle
directly into my heart.

Thank you for not assuming all ghosts wear white.

I'm so grateful that orgasms shake me apart,
dismembered by pleasure, the shrapnel of rapture.

Thanks to the Divine Watchmaker
for assuring that all points of view remain skewed.

 (No more beachy piggybacks
 that leave only one set of footprints,
 eh, Big Guy?)

Thank you for the deformation of character,
victimless crimes, and false witness.

Thanks for my own murderers attending my funeral.

For my true friends: champagne.
For my sham friends:
true pain. Thank you
for teaching me the value

of suffering
for art. This is
indeed
my finest hour.

ALTERNATE ENDINGS

I

The cop out: you wake up
snug as a beetle in dung
and this was all a dream.

You snap the book shut
and I have never been.
Roll credits.

II

The Hollywood ending: moist cheeks and pop music. Characters each reap what they've sown. Stitches hold. The director double-knots the plot, leaves no loose ends or epilogue. He clips threads with a full set of teeth. Our hero gets the girl—or someone rather human. They kiss: horses gallop on the beach and no legs break. *Wild, wild horses couldn't drag me apart.* Happy ever after.

You slay me, reader. You tear

 out my pages like a polar bear

kicking up the snow.

Look at me, all smithereens, yet still alive.
I dedicate each film to you.
I spit my teeth and offer them.
I doff the crown
of my skull to you, dear reader.

 Can you not read the inscription?

Hebrew burnt into the bone

 [Don't you read Hebrew? Where were you
 educated?]

Run your fingers over it

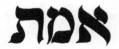

Emet. La vérité.

Truth.

Emmett. Male. Variant of Emma,

 Old German origin.

 Meaning: "Universal."

How seamless.

Emmett. *Emet.*

The living, crippled truth.

Film shows everything

 but reveals nothing.

 Did I request thee, Maker, from my clay

Father, look at me. Your boy blasphemes
merely by existing. I could crack your rib cage

 and free your heart forty times

 [the French for "forty" is *quarantine*]

 and not be slaked. No formula for that
in all of alchemy.

What science can undo your sorcery?

[slake: *v.* 1. satisfy

 2. combine quicklime with water]

Dear reader, God-warm audience, please

kill me dead. Erase the aleph inside my skull.

Smash it with a rock, you tiny David

I will put sinews on you and bring flesh upon you,
cover you with skin and put breath in you; and you
shall live

{Enter gagging. Address the clotted audience.}

"My throat a viscous loch." {Sing}

Living tissue, warm flesh

Weird science

Oh crowd, go wild
just once more.
Rip me up like Orpheus

[Closing shot: the severed head, his mouth
still beautiful, still singing]

Look at me.

Look. At. Me.

Crack this code

and wipe my skull clean

like a dish

[Slow dissolve]

Oh crowd, go wild.

I swear this is the last thing I—

ACKNOWLEDGEMENTS

Firstly, to Mary Shelley. Witch, muse, radical woman.

To Scott James Magner and ARUS Entertainment, who asked to publish this manuscript. Father of the Bride. Big Daddy.

Most abundant thanks to my family: Mom & Dad, Danielle and Neil, Kent, Braden and Nolan, all the cousins and aunties and uncles, to the ancestors before and the descendants to come. To all my lovers, brief and lasting.

To my mentors who taught me the poetry: Mom, David Kirby (il migliore blurbologist), Ginny Grimsley, and all the professors at Florida State University. Thanks to my defense committee, including David, Barry Faulk, Barbara Hamby, and James Kimbrell, for all the insights on this manuscript. To all the women who taught me how to write.

To Moon Patrol for breath-stopping cover art and Honor Zavatta-MacDonald for a painstaking cover design.

To Everett Considine and Julian Kowalski for love and exorcisms. To Jonathan Dean for music, magic, 909s and thought crimes. To Doug Powell and Clive Barker—you filthy, flawless angels.

To the Seattle, Tallahassee, and Miami writing communities for repeatedly putting me on stages. To the publishers and editors who released these poems individually before now.

To the writers and chums throughout school, from FSU to Clarion West. To the writers, directors, actors, and crews who made the films and artworks that inspired these poems.

To the blurb writers who honor me with their blessing.

To the Spirit and the spirits: Mercury and Venus, Eros and Anansi, Thoth and Kali, Spider, Coyote, Fox, Hummingbird, Peacock, Phoenix, Unicorn, Lovecraft, Ginsberg, Plath, Artaud, Burroughs, and Bowie. Ah, Bowie.

Thank you, Dear Reader, for this secular exorcism. Like the angry villagers who set us ablaze just to watch us crisp, let us thank God.

Evan J. Peterson
June, 2021

A GREAT CAST DESERVES REPEATING

The following members have been published, often in other forms or with different titles, in the following journals and anthologies:

"Rebirth is Always Painful," "Dyscephalus," "Creature of the Night," and "Little Pine Eye" in print in *Weird Tales* and in audio by *Pseudopod*

"Franken Berry?" in *Court Green*

"Dumbshow" in *Lo-Ball*

"The Cinema of Cruelty," "Die Young, Stay Pretty," "Every Now and Then I Fall Apart," "A Fly on the Lens," "Gods and Monsters," "Intermission," "Long Live Death," and "The Watermark" in *Assaracus*

"Cut-up 2: Retrofuturist Manifesto" in *Small Doggies 1*

"Alternate Endings," "The Bandage Motif," "The Black Dahlia Review," "The Creature Confesses," and "Drive-In Palimpsest" at *SmallDoggies-Magazine.com*

"I Heart Udo Kier" in *NANOfiction* and *We Like It Fast*

"The Dead Still Hear and Feel," "Frankenstein to Frankenstein," "Shower of Silver," and "The Wunderkammer" in *Studies in the Fantastic*

"All Your Gorgeous Garbage," "Die Puppe," and "Museum of Obsolescence," in *specs*

"Acceptance Speech for a Posthumous Oscar" and "Bring Me the Head of Cloris Leachman!" in *Eudaimonia Poetry Review*

"How He Came into the World" in *Poetica*

"Box Office Poison" in *blossombones*

"The Piss-Test Cathedral" in *Entasis*

"Rebirth is Always Painful" in *Aim for the Head: An Anthology of Zombie Poetry*

"Wunderkammer" in *Drawn to Marvel: Poems from the Comic Books*

"His Name is in Me" and "One Breast" in the *Ganymede Unfinished* anthology

"Otto, or: Up With Dead People" appeared in the chapbook *The Midnight Channel* (2013 Babel/Salvage)

The poems "How He Came into the World," "The Piss Test Cathedral," "Box Office Poison," "Creature of the Night," "The Cinema of Cruelty," "Dyscephalus," "A Fly on the Lens," "Rebirth is Always Painful," "I Heart Udo Kier," and "Acceptance Speech for a Posthumous Oscar" appeared in the chapbook *Skin Job* (2012 Minor Arcana Press)

HEADSTONES FOR ROBBED GRAVES

"Cut Up: Hideous Progeny" is created entirely from words and phrases from Mary Shelley's 1818 *Frankenstein*.

"All the Electrical Secrets of Heaven" contains quotes from the film *Frankenstein* (Whale, 1931)

"In the Arctic" contains the quote, "Use my body to keep you alive!" from *La venganza del sexo* a.k.a.The Curious Dr. Humpp (Vieyra, 1971). The quote also appears in Rob Zombie's "Never Gonna Stop."

"Cut Up: Retrofuturist Manifesto" is created entirely from words and phrases sampled from F. T. Marinetti's *Manifesto del Futurismo* (*Futurist Manifesto*) and Mary Shelley's 1818 *Frankenstein*.

"Made for TV" contains lyrics from the Blondie song "Atomic."

"Go Nameless" contains lines from Christopher Isherwood and Don Bachardy's mighty queer Frankenstein: The True Story, directed by Jack Smight. The poem also contains a line from *Macbeth*.

"I Heart Udo Kier" contains lyrics from the Soft Cell song "Sex Dwarf."

"The Cinema of Cruelty" is rife with references to the work of Antonin Artaud. The line "The poetry of meat" is a reference to Cronenberg's *The Fly*

"Creature of the Night" contains lyrics from *The Rocky Horror Picture Show*.

"Dyscephalus" contains a line or two from David Lynch's *The Elephant Man*.

"Box Office Poison" contains sampled dialogue from the film *Mommy Dearest* (Perry, 1981).

"The Bandage Motif" contains the phrase, "God loves, man kills," the title of an *X-Men* graphic novel (Claremont, 1982).

"Cut Up: Optimum Shelley Auto Crash" is created entirely from words and phrases sampled from J. G. Ballard's essay, "Why I Want to Fuck Ronald Reagan," (a precursor to his novel *Crash*), and Mary Shelley's 1818 *Frankenstein*. There's a lot of Cronenberg in there. In this entire book, honestly.

"Die Young, Stay Pretty" is also the title of a Blondie song. *I Was a Teenage Frankenstein* is the title of a 1957 horror film. "'Teenage Frankenstein" is also an Alice Cooper song.

"Rebirth is Always Painful" contains the title lyric of Coil's "Teenage Lightning."

"Every Now and Then I Fall Apart" is, of course, a lyric from Bonnie Tyler's "Total Eclipse of the Heart," written by Jim Steinman.

"Otto; or Up With Dead People" is the title of a Bruce LaBruce film. "The Revolution is [my] boyfriend" is a slogan from LaBruce's film "The Raspberry Reich." This poem also contains lyrics to the song "Everyone's Dead" by the Homophones. All similarities to white supremacist iconography are purely intentional.

"Alternate Endings" contains a verse, Ezekiel 37:6, from the Old Testament and lyrics from Oingo Boingo's song "Weird Science." א מ ת or "emet" is Hebrew for "truth." In some golem legends from Jewish folklore, the word "emet" brings the golem to life when inscribed on the head. Erasing the aleph (א) deactivates the golem, leaving the word "met" or "dead." "Did I request thee, Maker, from my clay" is a quote from John Milton's *Paradise Lost* and features in Shelley's *Frankenstein*.

ABOUT THE AUTHOR

(img: Ian Johnston & Dangerpants Photography)

Evan J. Peterson is a 2015 Clarion West writer, horror and humor author, poet, critic, and game writer. In 2017, he published THE PrEP DIARIES: A SAFE(R) SEX MEMOIR, the world's first book about the HIV-treatment breakthrough Truvada, through Lethe Press. In 2019, Evan published DRAG STAR!, the world's first drag performance RPG, through Choice of Games.

Evan is also the volume editor of the Lambda Literary Award finalist GHOSTS IN GASLIGHT, MONSTERS IN STEAM: GAY CITY 5. His fiction, nonfiction, and poetry have appeared in Best Gay Stories 2015, Weird Tales, Nightmare Magazine, The Stranger, The Rumpus, The Queer South Anthology, Unspeakable Horror 2, Queers Destroy Horror, Drawn to Marvel: Poems from the Comic

Books, Arcana: The Tarot Poetry Anthology, and Aim for the Head: An Anthology of Zombie Poetry.

He was the founding Editor-in-Chief of Minor Arcana Press and the founder/producer/host of the SHRIEK: Women of Horror Cinema series in Seattle. He currently lives in Seattle with his dog, Dorian Greyhound.

You can catch up on all things Evan at his website

http://evanjpeterson.com/

on Twitter
@evanjpeterson

or on Facebook
Facebook.com/evanjpeterson